T0070498

IMAGING BY NUMBERS

A HISTORICAL VIEW OF THE COMPUTER PRINT

DEBORA WOOD

PUBLISHED IN CONJUNCTION WITH AN

EXHIBITION CURATED BY PAUL HERTZ AND DEBORA WOOD

MARY AND LEIGH BLOCK MUSEUM OF ART

NORTHWESTERN UNIVERSITY

CONTENTS

By their very nature, the graphic arts have always been wedded to technology. Coinciding with the invention of printing, early woodcuts and engravings relied upon the capabilities of a mechanical press for their production. Is it any wonder that the tool that is rapidly superseding the printing press, the computer, has inspired new ways to create art? As the printing press both empowered and defined the possibilities for the graphic arts from the 15th century onward, the computer and its algorithmic language offered unique possibilities to create wholly new kinds of imagery since the mid-20th century.

This publication and exhibition, *Imaging by Numbers: A Historical View of the Computer Print,* is a manifestation of the Block Museum's core mission to study and exhibit multiples and electronic art forms—including prints, photographs, film, video, and computer-mediated art—and to articulate their unique capacities to reach and transform society.

Imaging by Numbers is the marvelous result of an eight-year collaboration between Block Museum senior curator Debora Wood and Paul Hertz, who teaches and develops interactive multimedia applications at Northwestern University and is the multimedia applications developer of Northwestern University's Collaboratory Project. As evidenced in this publication, they have reached out and engaged an international group of theorists, pioneers, and current practitioners in digital printmaking in writing this history. I thank them both for their contributions to this project, and I know they share with me the grateful acknowledgment of the Museum staff and supporters for their assistance.

A project such as this would not have been possible without the support of those who made works from their collections available to broaden the scope of the exhibition: Kunsthalle Bremen—Kupferstichkabinett—Der Kunstverein in Bremen (Germany); the Spencer Museum of Art, University of Kansas; Anne and Michael Spalter; and Marion Parry. Director Steven Sacks and assistant director Laura Blereau at bitforms gallery in New York; director Natalie Domchenko of the Peter Miller Gallery in Chicago; and Philadelphia Museum of Art assistant curator of prints and drawings Shelley Langdale have been extremely helpful with their timely communication of information about artists and their work. Thanks go to everyone on the Block Museum staff for their extraordinary dedication, attention to detail, and high professional standards, which have helped bring this project to fruition. The generosity of funders is essential for such a project. We are grateful to C. Richard Kramlich for his generous support and to Flashpoint, The Academy of Media Arts and Sciences, for its sponsorship. We also thank the Illinois Arts Council, a state agency; the Lawrence Kessel Bequest Endowment; ACM SIGGRAPH; Hewlett-Packard; the Myers Foundations; and American Airlines for their support.

Finally, we would like to thank the artists in this exhibition, many of whom lent works of art to the show and also graciously gave their time to answer a variety of questions about their work, history, techniques, and philosophies. It is through these collaborative efforts that we are able to present a history of the computer print.

DAVID ALAN ROBERTSON
The Ellen Philips Katz Director

IMAGING BY NUMBERS: A HISTORICAL VIEW OF THE COMPUTER PRINT

Since the technology of electronics has become such an important part of modern life, it is inevitable that it be employed in the creation of art. —BEN F. LAPOSKY[1]

Ben F. Laposky (1914–2000), a mathematician and artist from Cherokee, Iowa, was intrigued by the beauty inherent in waveforms and scientific graphs. In 1952 he was the first to create graphic images with an electronic analog machine. Using high-speed film, Laposky photographed his manipulated electronic waveforms (Lissajous figures) as they flickered across the screen of an oscilloscope. The following year an exhibition of Laposky's photographs, or *Oscillons,* was organized by the Sanford Museum in Cherokee and traveled throughout the United States. In 1955 in Erlangen, West Germany, Herbert W. Franke (born 1927), also a mathematician and artist interested in experimental photography, began photographing a smaller oscilloscope screen that displayed modified electronic waveforms. The work of Laposky and Franke represents the beginning of an international interest in art created with computers as well as the foundation of the digital computer print.

The exhibition *Imaging by Numbers: A Historical View of the Computer Print* explores the development of computer programming as a medium for artistic expression in creating prints, drawings, photographs, and artists' books. The exhibition features works from 1952 to the present by 39 North American and European artists who use algorithmic processes and the concept of randomness to create computer prints. An algorithm is defined as a clearly delineated step-by-step procedure, usually used for solving mathematical problems. In computer graphics, an algorithmic program is written to "instruct" the computer how to draw an image. Frequently a random element is incorporated into the procedure, such as repeating a step that would create variations of a form or allow certain parameters to be interchanged. By incorporating an element of random selection in the computer program, not only is the final composition unknown, but endless variations of the composition can be produced. Most of the artists represented in *Imaging by Numbers* write their own software or employ software designed to support algorithmic processes, although they may use commercial applications to edit and print their work. Others manipulate commercially available applications in directions beyond their intended use.

The first computer artists came from a variety of professions and backgrounds, but most commonly they were engineers and mathematicians working in industry and academia. These individuals had access to computers and the technical knowledge to use them. They believed in the creative potential of technology beyond purely utilitarian applications. In the mid- to late 1960s many traditionally trained artists were attracted to the potential of the computer as a tool to make art. They taught themselves to program computers in order to have complete control over the output and more fully realize their visions.

Influential to many of these pioneering computer artists were the writings and activities of Strasbourg-born philosopher and professor Max Bense (1910–90), who founded the Studiengalerie der Technischen Hochschule in Stuttgart and directed it from 1958 to 1978. A defender of computer art as a valid and important form of aesthetic expression, Bense held that art and mathematics were very closely connected. He saw transparency of technique—the clear revolution of the artist's procedure in the final work—as a means of obtaining spiritual purity in art. Also influential to many computer artists was French physicist and philosopher Abraham A. Moles (1920–92), who wrote many theoret-

ical treatises on process, or computational, art in the 1950s and 1960s. His ideas of randomness as applied to algorithmic or creatively driven mathematical programming were seminal to computer art.

Many universities, particularly in the United States, helped foster cross-cultural experimentation between the sciences and the arts. As computer technology grew across disciplines in the 1970s and 1980s, artists began pushing the boundaries of what computers were capable of producing. Color printers were not readily available, and those that were could not produce the same vibrant colors that could be achieved through traditional printmaking processes. The production of multiple computer-generated prints to create an edition could also be time-consuming, particularly with early computer processors. There were strict size limits to digital prints, requiring tiling if large works were desired. Some artists used the computer as a starting point for their imagery but reserved traditional print processes for the final composition. Photographic negatives were made from smaller black-and-white computer prints so that the imagery could be transferred to screen, stone, or plate and printed traditionally in color or at a larger scale if desired. This not only integrated computer technology in the creation of art but also complied with the conventions of fine art printmaking. Other artists conceived new applications for printing devices, such as using plotters to draw with graphite or watercolor on a variety of papers, or combining dot matrix or laser prints with letterpress, woodcut, and lithography.

As computer software and computer-human interfaces evolved, artists were able to work with greater precision by using software with graphical user interfaces. Digital paintbox, image processing, and drawing applications software incorporated procedures and symbolic icons that resembled traditional painting, photography, and drawing tools, opening computer applications to a wider range of artists. Regardless of the advances in user interfaces and commercial software, there are artists who continue to write their own programs; they are interested in using the computer for its unique capabilities that differentiate it from other media, not as a means of replacing traditional media.

The current rising generation of computer artists is engaged in writing its own software and applying algorithmic methodology to the creation of animations and installations in addition to computer prints. American artist C.E.B. Reas (born 1970) has said, "Working in software allows me to engage the live process and to change its parameters to affect the way it behaves, while working in print gives me the opportunity to examine the state of the process at a specific point in time with extremely high fidelity."[2] Just as the pioneers in computer art wrote a sequence of actions, defined interactions of elements, and established parameters for the computer to process and generate imagery, a new generation of artists such as Reas are engaged in algorithmic processes to create artworks that could not exist through any means other than through computer programming. Laposky's statement on the profound integration of electronics into modern life is echoed with the advent of accessible digital technology. As technology has changed culture and society, so has it profoundly influenced art and the art of the print.

DEBORA WOOD
Senior Curator

1. Ben F. Laposky, "Oscillons: Electronic Abstractions," *Leonardo* 2, no. 4 (October 1969): 345.

2. C.E.B. Reas, *Process/Drawing* (Berlin: DAM, 2005), n.p.

Artists in the Exhibition

Charles Jeffries Bangert and Colette Stuebe Bangert

Kim Beckmann

Otto Beckmann

Peter Beyls

Paul Brown

Harold Cohen

Charles A. Csuri and James Shaffer

Joshua Davis

Hans Dehlinger

Pascal Dombis

David Em

Sherban Epuré

Herbert W. Franke

Lane Hall and Lisa Moline

Leon D. Harmon and Kenneth C. Knowlton

Jean-Pierre Hébert

Richard Helmick

Ben F. Laposky

John Miller

Manfred Mohr

Vera Molnar

Kamran Moojedi

Frieder Nake

Georg Nees

A. Michael Noll

James Paterson

Sonya Rapoport

C.E.B. Reas

Tony Robbin

Jason Salavon

Joan Truckenbrod

Roman Verostko

James Faure Walker

Mark Wilson

Edward Zajec

Following are reproductions of selected works from the exhibition *Imaging by Numbers: A Historical View of the Computer Print* arranged in chronological order.

To standardize the language used to identify media, technique is listed rather than brand names or invented terms which can be subject to corporate promotion or fads. For example, *inkjet print* is listed rather than *Iris print* or *giclée*. In two cases, the photographic technique could not be concretely identified, hence "photograph" is listed. Because computer graphics are inseparable from process and technology, software and both make and model for computers and output devices are listed, but often this information has been lost. Most of the works exist as unique impressions or very small editions (less than 40).

Dimensions are in inches; height precedes width precedes depth. Framed works in private collections were not unframed for measurements. In these cases, only frame size is included.

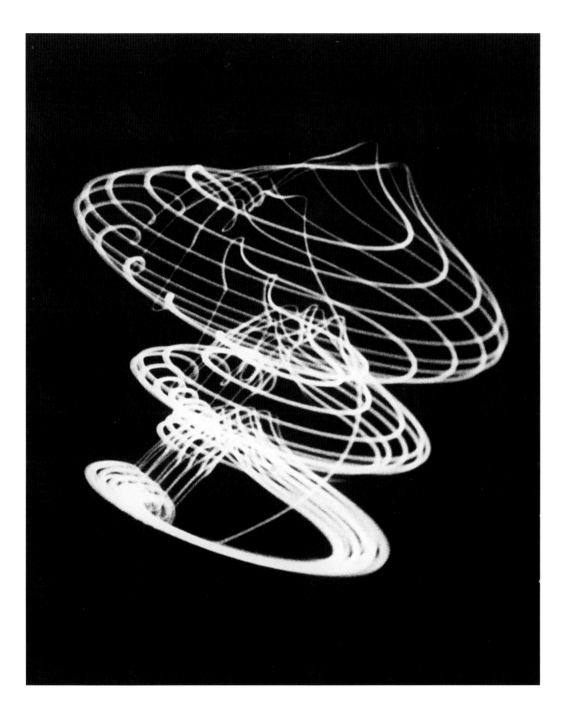

A. MICHAEL NOLL (American, born 1939), *Computer Composition with Lines*, 1964. Photograph of microfilm plotter drawing. Software by the artist in FORTRAN; hardware: IBM 7094; output device: Stromberg-Carlson SC-4020 microfilm plotter. Sheet: 11-1/16 x 8-1/4 inches; image: 5-7/8 x 6-1/8 inches. Kunsthalle Bremen–Der Kunstverein in Bremen (Germany), Inv. Nr. 2006/439.

Ⓒ AMN 1965

COMPUTER COMPOSITION WITH LINES (1964)
BY A. MICHAEL NOLL

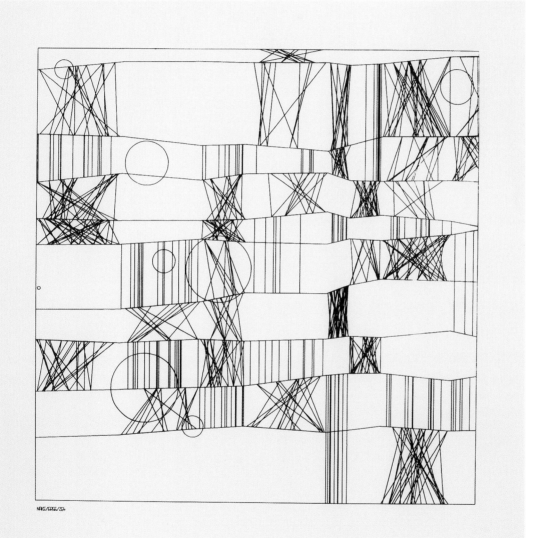

FRIEDER NAKE (German, born 1938), *Homage to Paul Klee, 13/9/65 Nr. 2.*, 1965. Plotter drawing, ink on paper.
Software, COMPART ER56, by the artist in ER56 machine language; hardware: STANDARD ELEKTRIK LORENZ ER56; output device: ZUSE Graphomat Z64.
Sheet: 19-7/16 x 19-7/16 inches; image: 15-3/4 x 15-3/4 inches.
Kunsthalle Bremen–Der Kunstverein in Bremen (Germany), Inv. Nr. 2004/147.

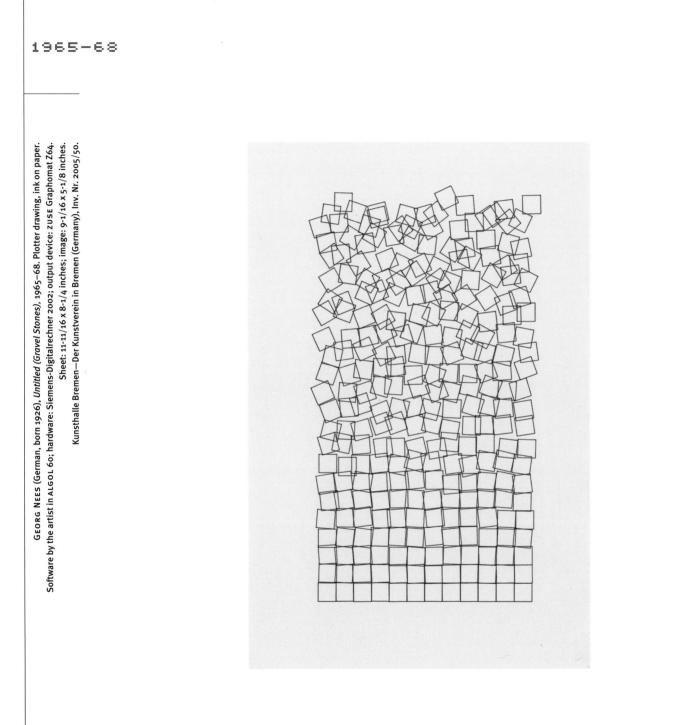

GEORG NEES (German, born 1926), *Untitled (Gravel Stones)*, 1965–68. Plotter drawing, ink on paper. Software by the artist in ALGOL 60; hardware: Siemens-Digitalrechner 2002; output device: ZUSE Graphomat Z64. Sheet: 11-11/16 x 8-1/4 inches; image: 9-1/16 x 5-1/8 inches. Kunsthalle Bremen—Der Kunstverein in Bremen (Germany), Inv. Nr. 2005/50.

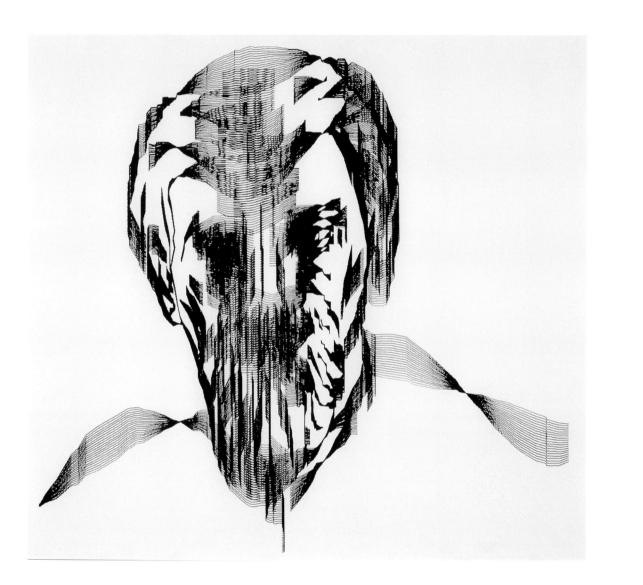

CHARLES A. CSURI (American, born 1922) and JAMES SHAFFER, *Sine Curve Man*, 1967. Photograph of a plotter drawing. Software by the artists; hardware: IBM 360; output device: IBM 1627 drum plotter. Sheet: 19-11/16 x 25-5/8 inches; image: 18-1/2 x 20-1/2 inches. Kunsthalle Bremen–Der Kunstverein in Bremen (Germany), Inv. Nr. 2006/402.

VERA MOLNAR (French, born Hungary, 1924), *Interruptions á recouvrements*, 1969. Plotter drawing, ink on paper. Software by the artist in FORTRAN; hardware: Bull; output device: Benson plotter. Sheet: 14-3/16 x 33-7/16 inches; image: 11-1/4 x 30-1/8 inches. Kunsthalle Bremen—Der Kunstverein in Bremen (Germany), Inv. Nr. 2006/2.

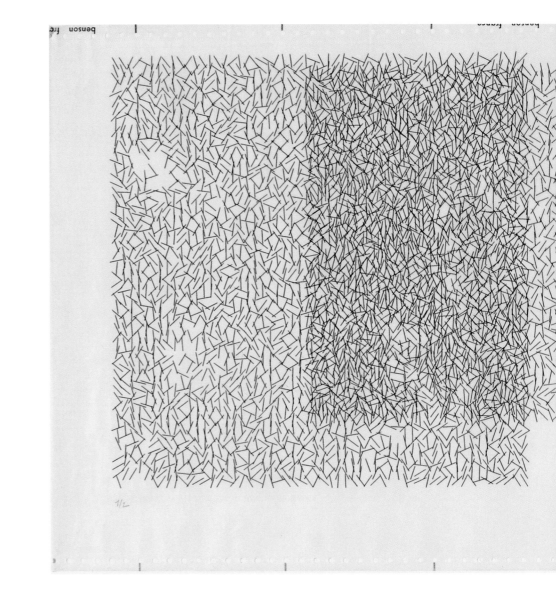

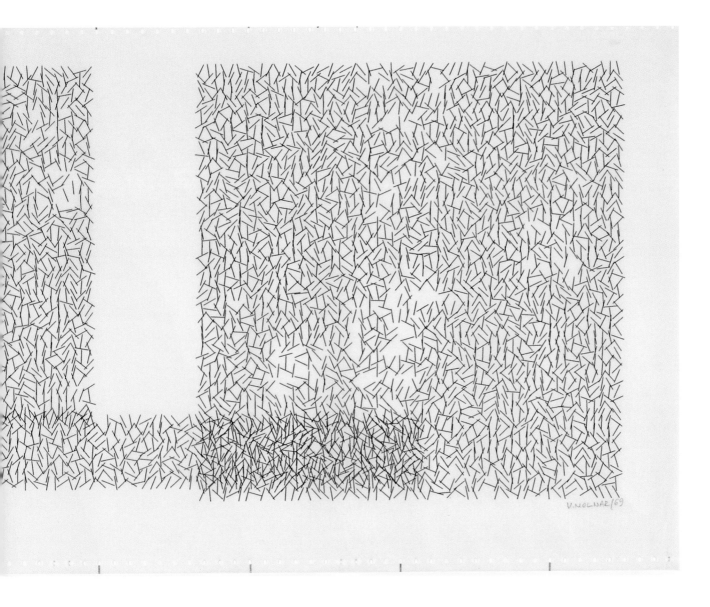

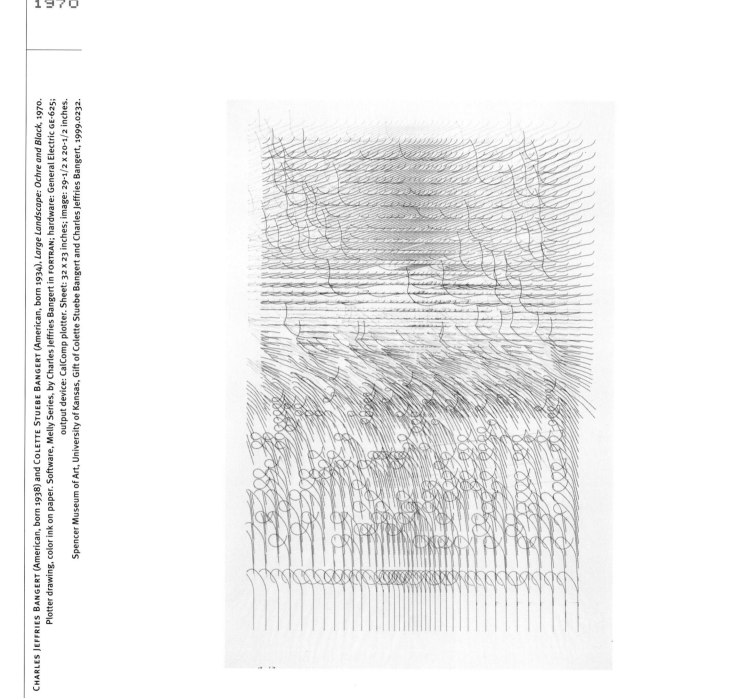

CHARLES JEFFRIES BANGERT (American, born 1938) and COLETTE STUEBE BANGERT (American, born 1934), *Large Landscape: Ochre and Black*, 1970. Plotter drawing, color ink on paper. Software, Melly Series, by Charles Jeffries Bangert in FORTRAN; hardware: General Electric GE-625; output device: CalComp plotter. Sheet: 32 x 23 inches; image: 29-1/2 x 20-1/2 inches. Spencer Museum of Art, University of Kansas, Gift of Colette Stuebe Bangert and Charles Jeffries Bangert, 1999.0232.

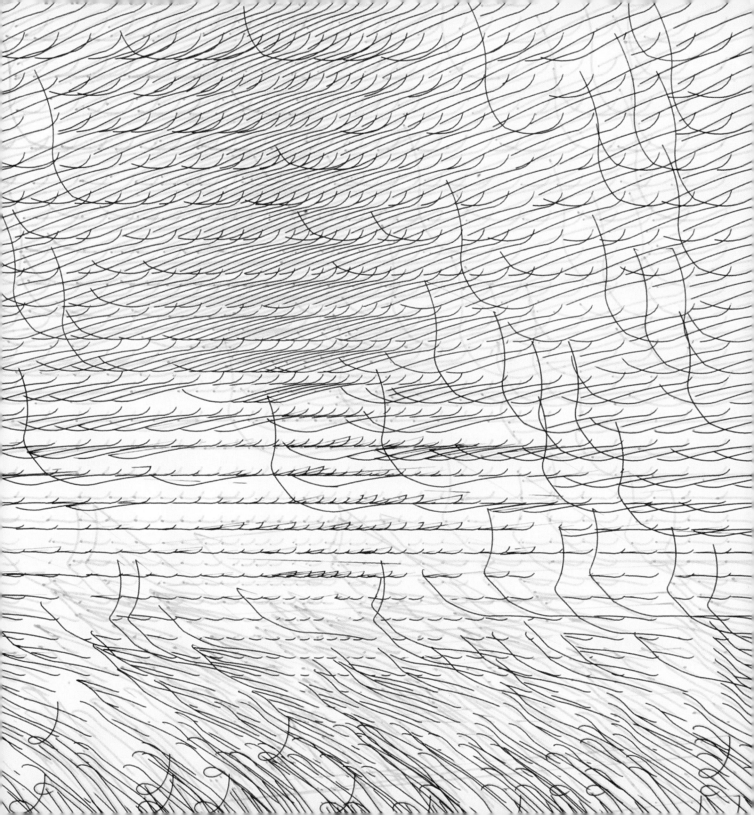

MANFRED MOHR (German, born 1938), *P-049 Formal Language, IR1=2*, 1970, drawn 1979. Plotter drawing, ink on paper. Software, Program 49, by the artist in FORTRAN; hardware: CDC 7600; output device: Benson-1084 flatbed plotter. Sheet: 19-5/8 x 19-5/8 inches; image: 17-3/8 x 17-3/8 inches. Mary and Leigh Block Museum of Art, Northwestern University, 2007.22.1.

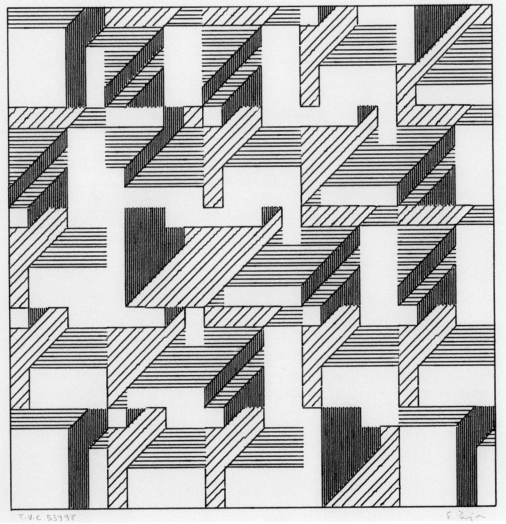

T.V.C 53998

EDWARD ZAJEC (Slovenian, born Italy 1938), *The Cube: Theme and Variations, TVC 53998*, 1973. Plotter drawing, ink on paper. Software, TVC, by the artist and Matjaz Hmeljak in FORTRAN IV; hardware: IBM 7044; output device: CalComp flatbed plotter. Sheet: 14-15/16 x 14-7/8 inches; image: 9-7/8 x 9-3/4 inches. Collection of the artist.

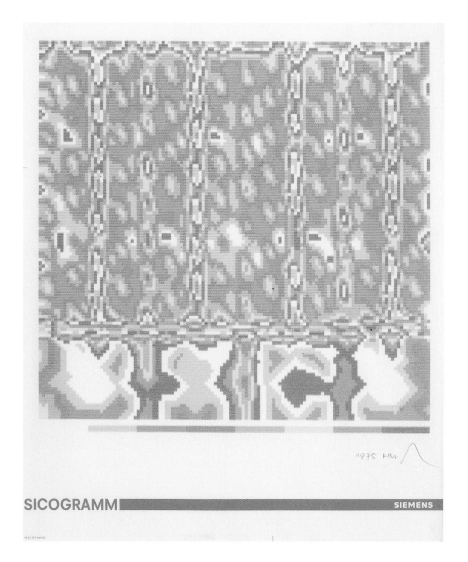

SICOGRAMM

SIEMENS

HERBERT W. FRANKE (German, born Austria, 1927), *Untitled*, from the series *Color Patterns 75*, 1975. Inkjet print. Output device: Siemens Sicograph. Sheet: 16-9/16 x 13-3/4 inches; image: 12-3/16 x 12-11/16 inches. Kunsthalle Bremen–Der Kunstverein in Bremen (Germany), Inv. Nr. 2000/212.

JOAN TRUCKENBROD (American, born 1945), *Electronic Patchwork*, 1978.
Color photocopy of computer monitor display transferred to polyester sheet.
Software by the artist in FORTRAN; hardware: Apple IIe; output device: 3M Color-in-Color photocopier.
Overall: 84 x 60 inches. Courtesy FLATFILEgalleries, Chicago.

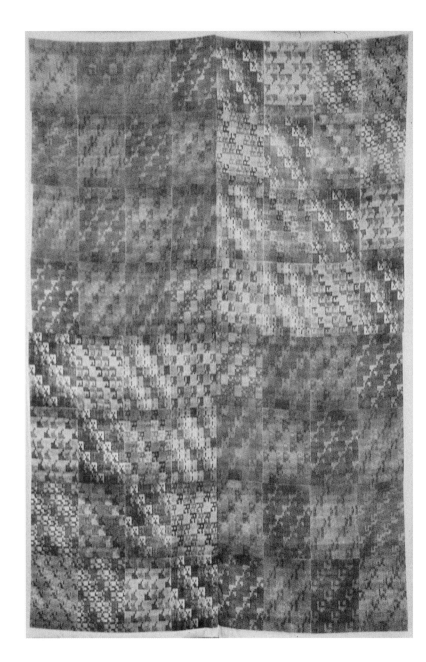

1979

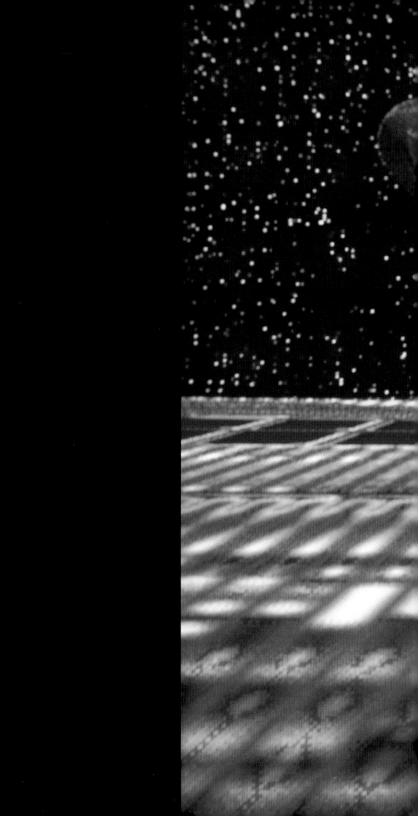

David Em (American, born 1952), *Transjovian Pipeline*, 1979.
Dye destruction print (Cibachrome) of computer monitor display.
Software by James Blinn and Jet Propulsion Laboratory; hardware: Digital Equipment Corporation PDP 11/70.
Sheet and image: 30 x 40 inches. Collection of the artist.

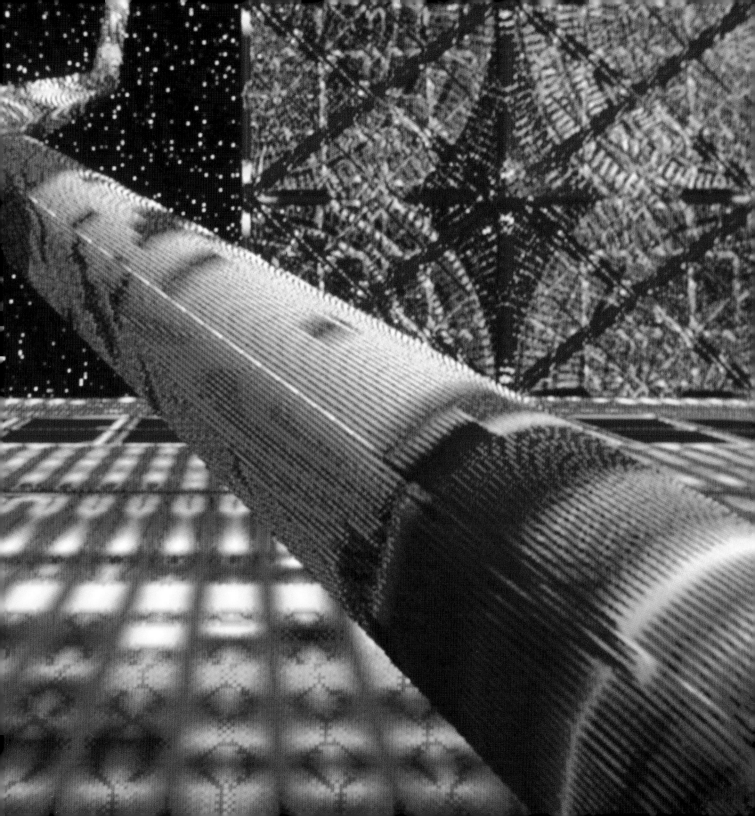

RICHARD HELMICK (American, born 1939), *American Sunset*, 1982. Screenprint from a dot matrix print. Software by Richard Helmick in BASIC; hardware: Apple II Plus. Sheet: 30-5/16 x 44-5/8 inches; image: 9-7/8 x 34-9/16 inches. Mary and Leigh Block Museum of Art, Northwestern University, Gift of the artist, 2007.10.

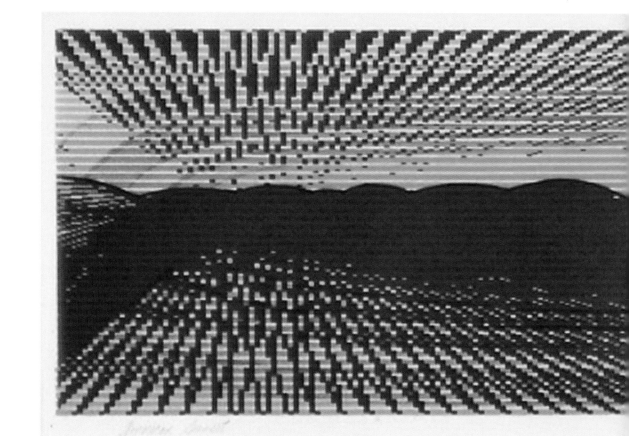

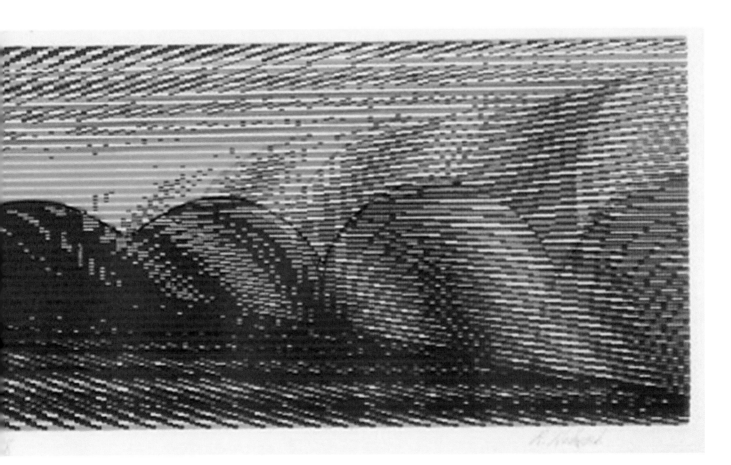

Sonya Rapoport (American, born 1923), *Shoe-Field Map*, 1982–85. Impact print on vellum. Software by the artist in BASIC II; hardware: CDC 6400; output device: line printer. Sheet: 45-5/8 x 23-5/8 inches; image: 41-1/2 x 14-3/8 inches. Collection of the artist.

Hans Dehlinger (German, born 1939), *Cube 4*, 1983, printed 1987. Screenprint from plotter drawing. Software by the artist in BASIC; hardware: Tektronix 4050; output device: Hewlett-Packard plotter. Sheet: 45 x 31-1/2 inches; image: 32 x 26 inches. Collection of the artist.

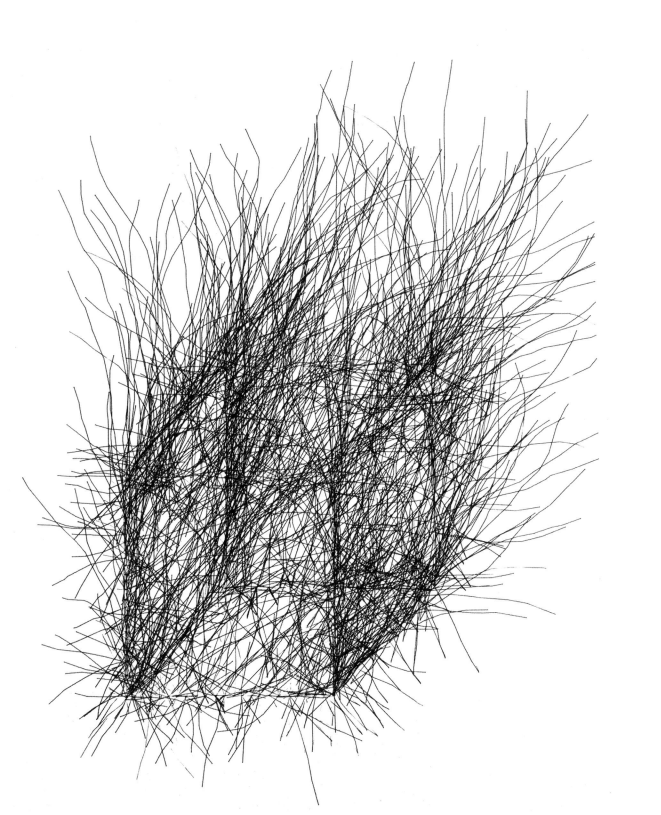

MARK WILSON (American, born 1943), *Long Skew G9*, 1985. Plotter drawing, color ink on paper. Software by the artist in BASIC; hardware: IBM; output device: Tektronix 4663 flatbed plotter. Sheet: 20-1/16 x 98-3/8 inches; image: 15-7/16 x 90-3/8 inches. Collection of the artist.

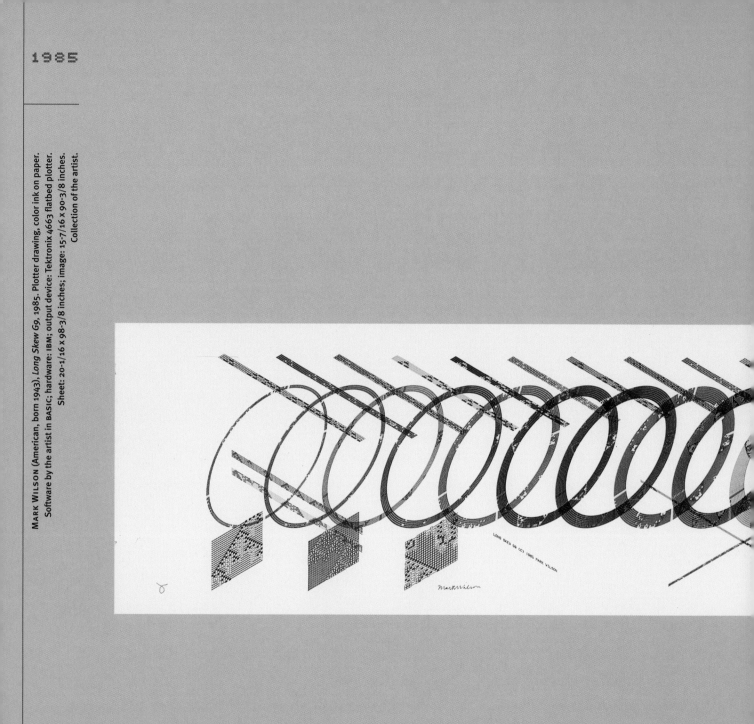

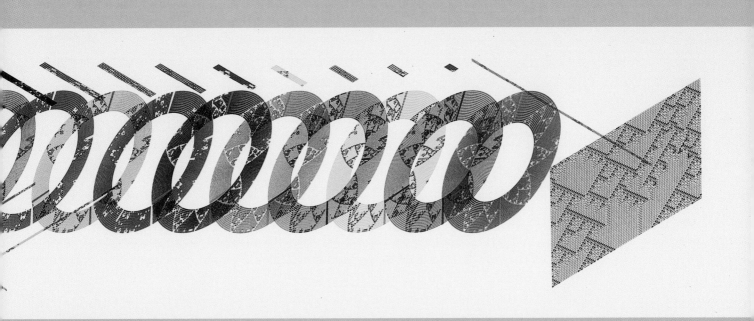

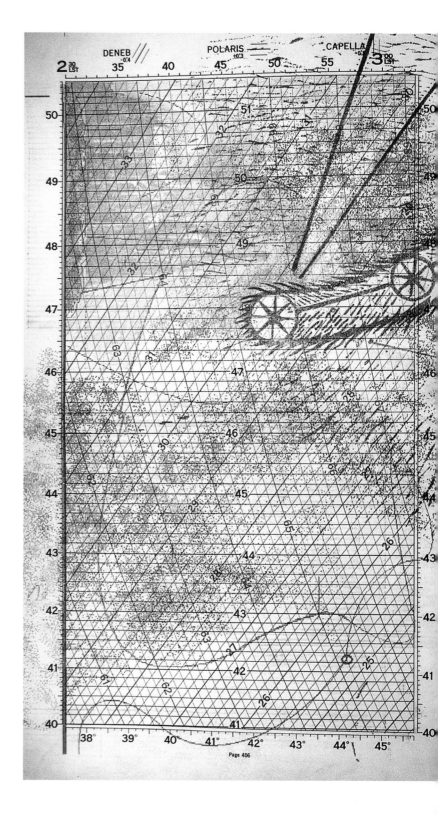

1989

LANE HALL (American, born 1955), *Traveller*, 1989.
Handmade book with dot matrix prints, letterpress, color lithographs, and woodcuts.
Software: Deluxe Paint II; hardware: Amiga 2000; output device: NEC 24 pin Pinwriter.
Closed: 14 x 8-1/2 x 1/4 inches. Collection of the artist.

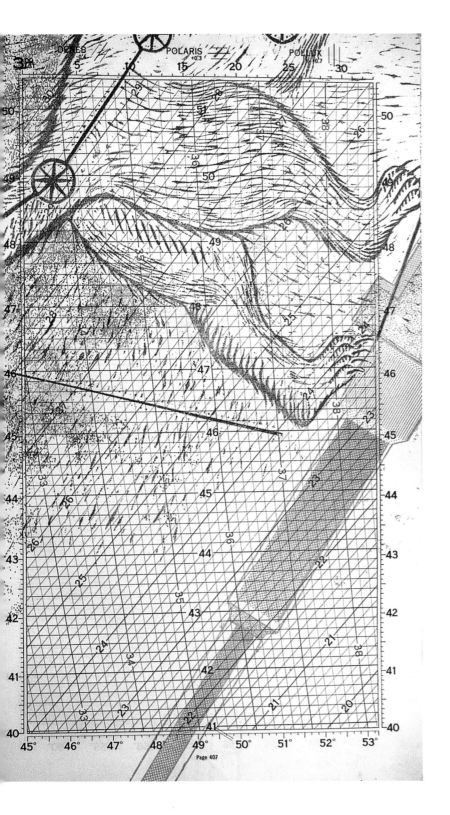

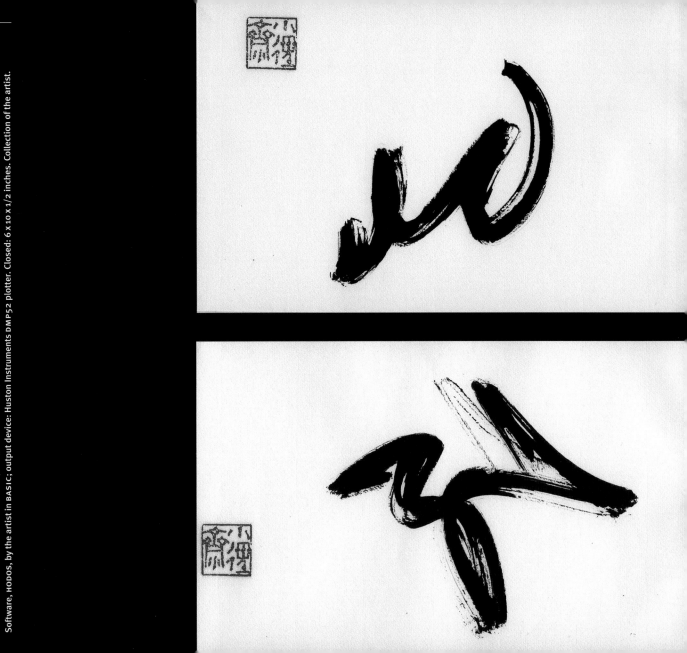

ROMAN VEROSTKO (American, born 1929), *Derivation of the Laws of the Operations of the Symbols of Logic from the Laws of the Operations of the Human Mind: An excerpt from the writings of George Boole*, 1990. Handmade book with plotter drawings in brush and ink and in pen and color ink, letterpress, and woodcut (2 pictured from an edition of 100, published by St. Sebastian Press, Minneapolis). Software, HODOS, by the artist in BASIC; output device: Huston Instruments DMP52 plotter. Closed: 6 x 10 x 1/2 inches. Collection of the artist.

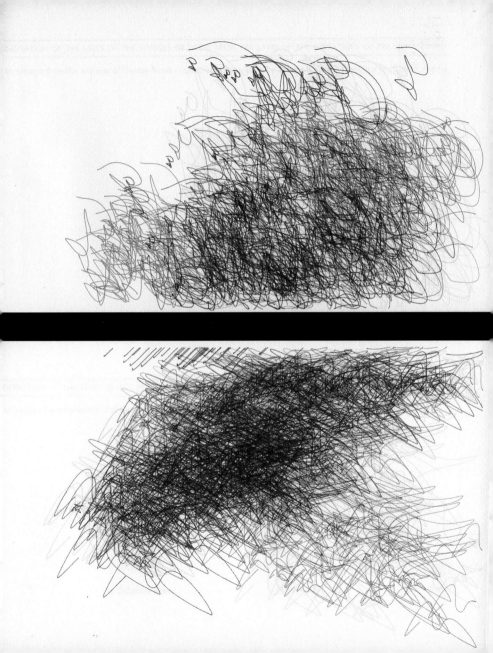

JEAN-PIERRE HÉBERT (American, born France, 1939), *Laque Noire (Black Lacquer)*, 1992. Plotter drawing, ink on paper. Software by the artist in Lisp; hardware: Sun Workstation; output device: Hewlett-Packard 7585 plotter. Frame: 32 x 32 inches; image: 19 x 19 inches. Collection of the artist.

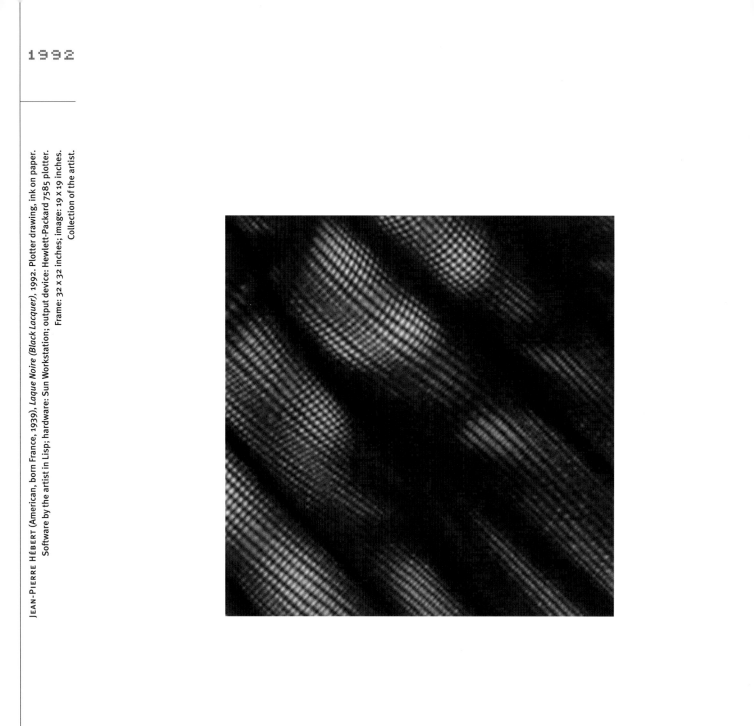

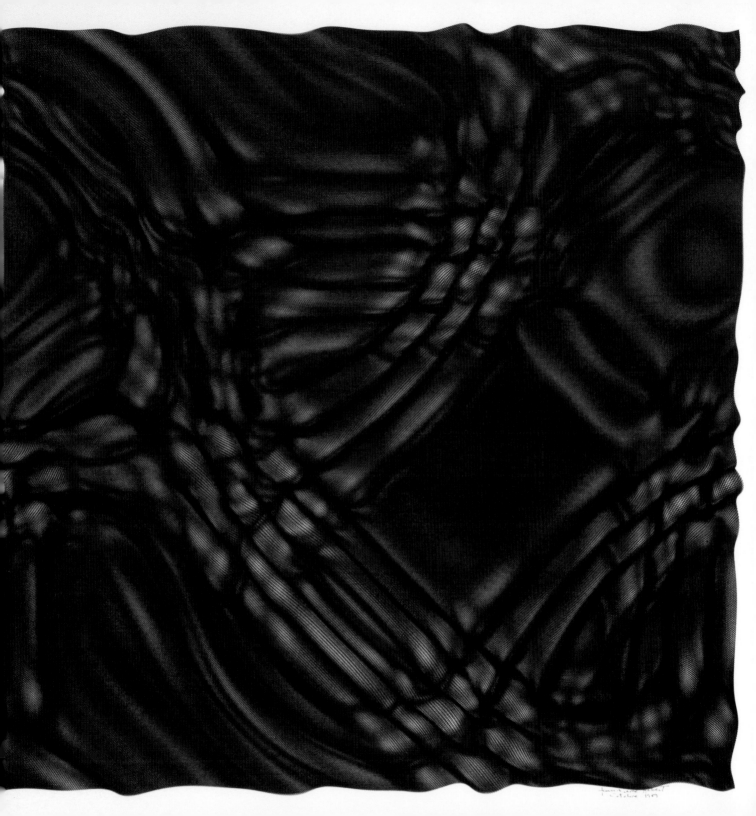

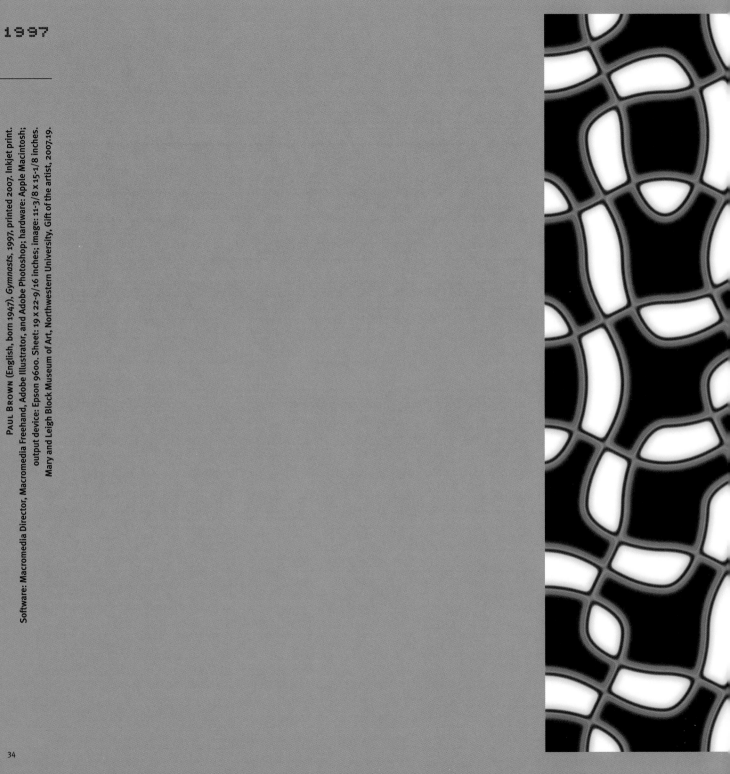

PAUL BROWN (English, born 1947). *Gymnasts*, 1997, printed 2007. Inkjet print. Software: Macromedia Director, Macromedia Freehand, Adobe Illustrator, and Adobe Photoshop; hardware: Apple Macintosh; output device: Epson 9600. Sheet: 19 x 22-9/16 inches; image: 11-3/8 x 15-1/8 inches. Mary and Leigh Block Museum of Art, Northwestern University, Gift of the artist, 2007.19.

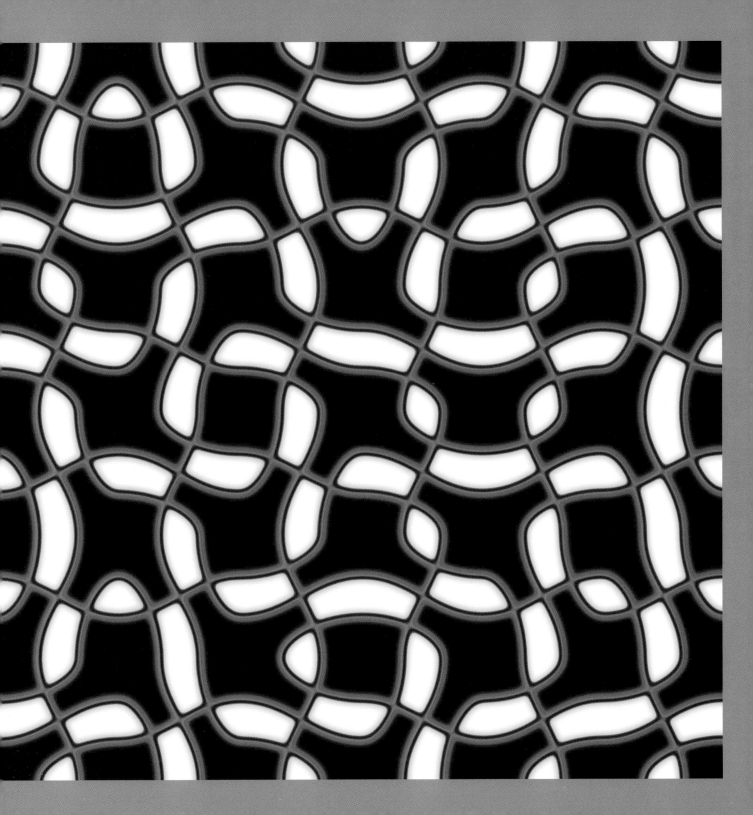

Pascal Dombis (French, born 1965), *Antisana II*, 2000, recreated 2008.
Site-specific installation, inkjet print on vinyl.
Software by the artist in PostScript; output device: EFI Vutek QS3200 UV-Curing printer.
Overall: 147 x 208 inches. Collection of the artist.

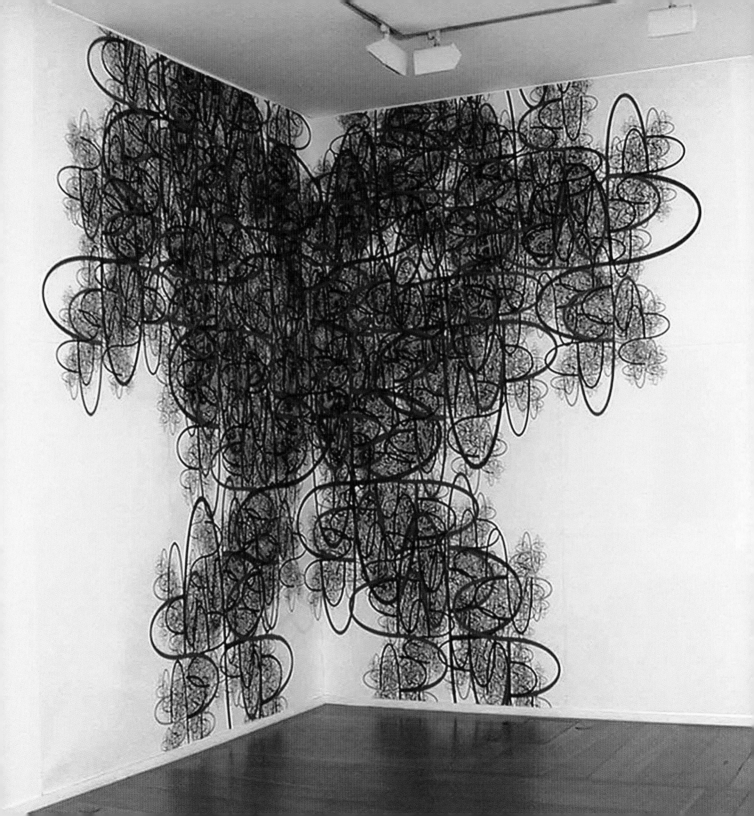

C.E.B. REAS (American, born 1970), *17*, from the series *Path*, 2001. Inkjet print. Software by the artist in C++ and OpenGL; output device: Epson 9600. Sheet: 34 x 34 inches; image: 32-1/4 x 32-1/4 inches. Mary and Leigh Block Museum of Art, Northwestern University, 2007.22.3.

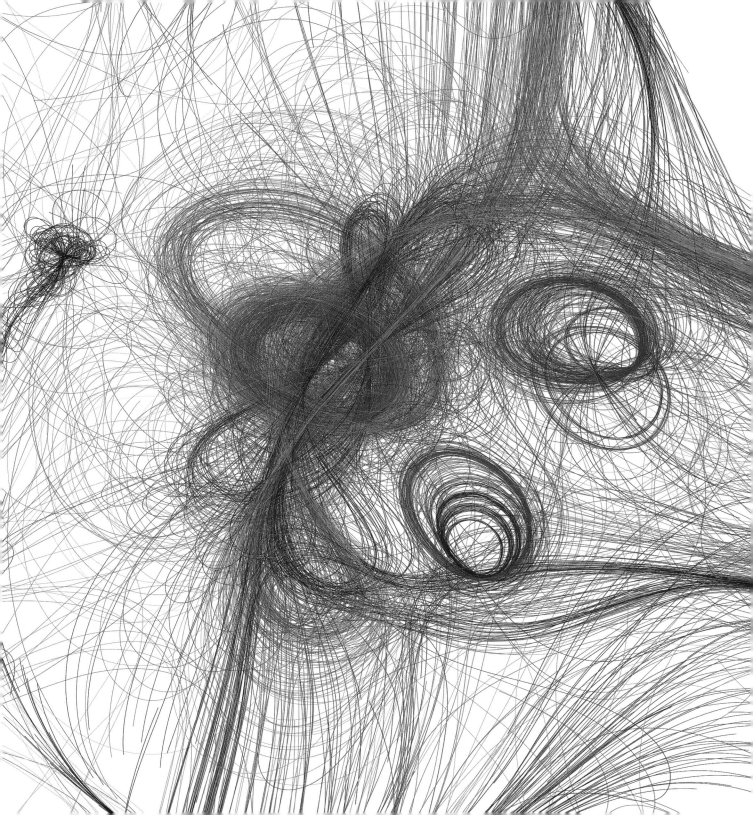

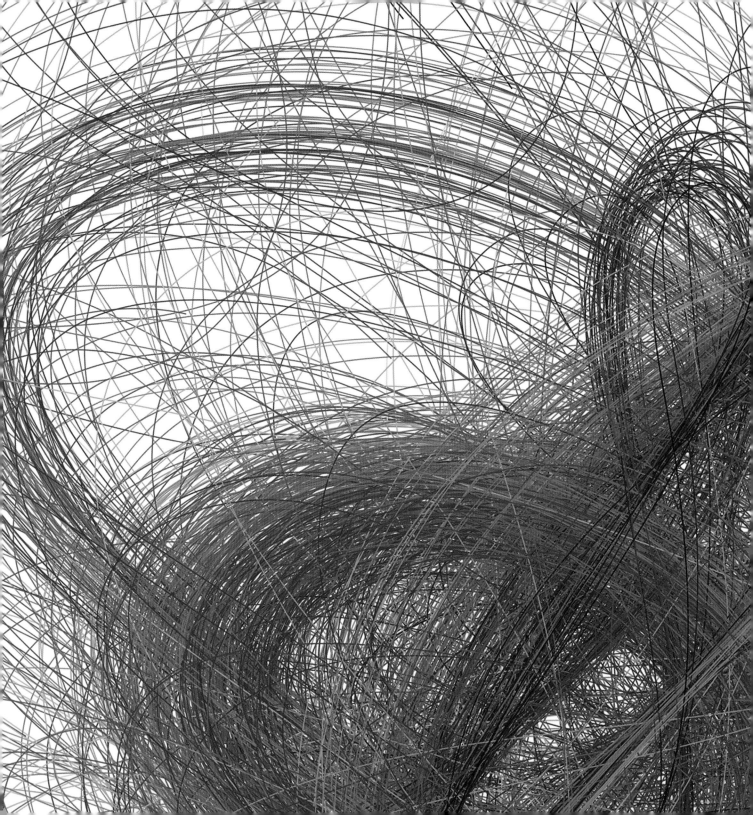

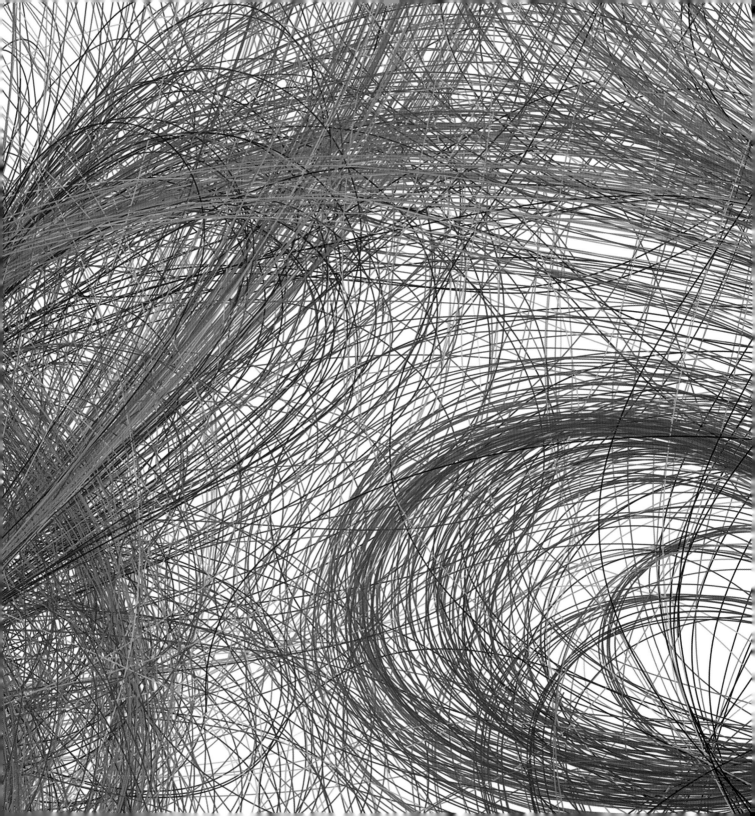

Tony Robbin (American, born 1943), *Drawing 53*, 2004. Inkjet print.
Software by the artist, Formian, and Adobe Illustrator; output device: Roland drum printer modified by Michael Gordon.
Frame: 42 x 48 inches; image: 32 x 40 inches.
Collection of the artist.

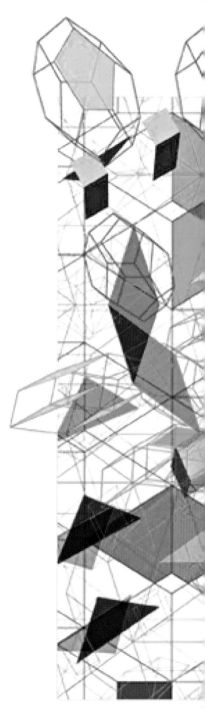

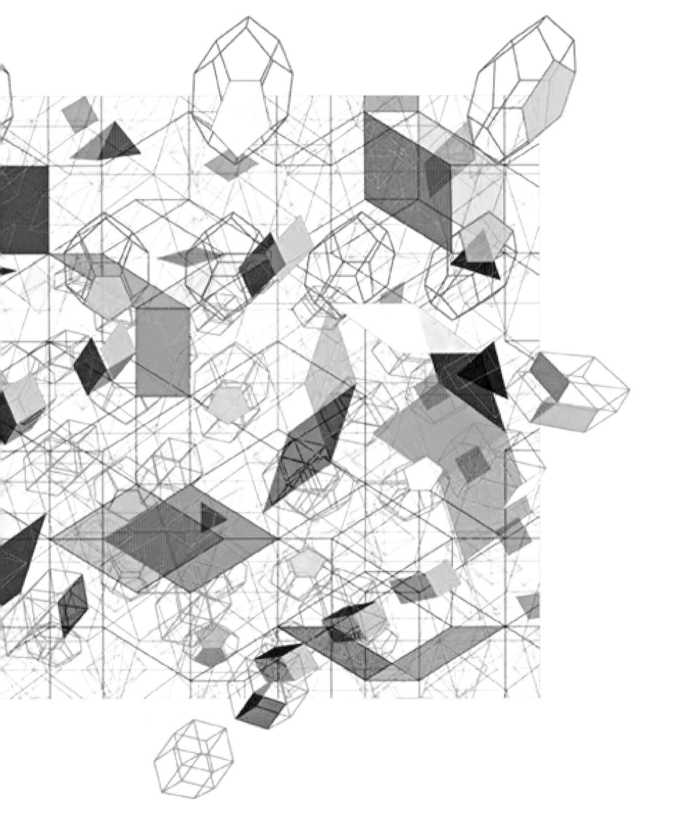

JOSHUA DAVIS (American, born 1971), *Amoeba*, from the series *Once Upon A Forest*, 2005. Inkjet print.
Software: Macromedia Flash and Adobe Illustrator; hardware: Apple Macintosh.
Sheet: 38-7/16 x 26-3/8 inches; image: 36-1/16 x 24 inches.
Mary and Leigh Block Museum of Art, Northwestern University, 2007.23.

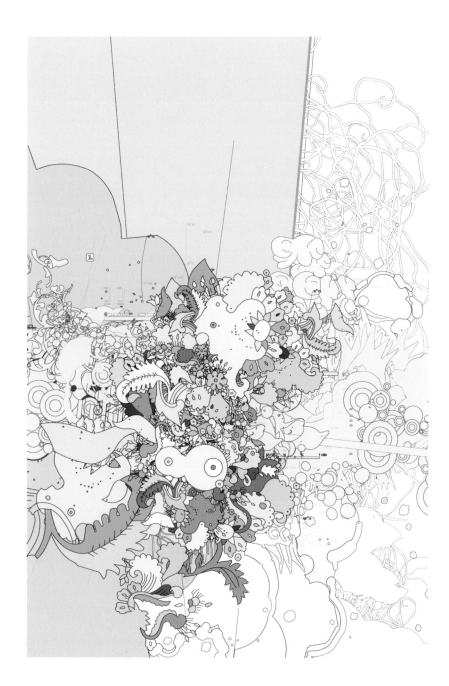

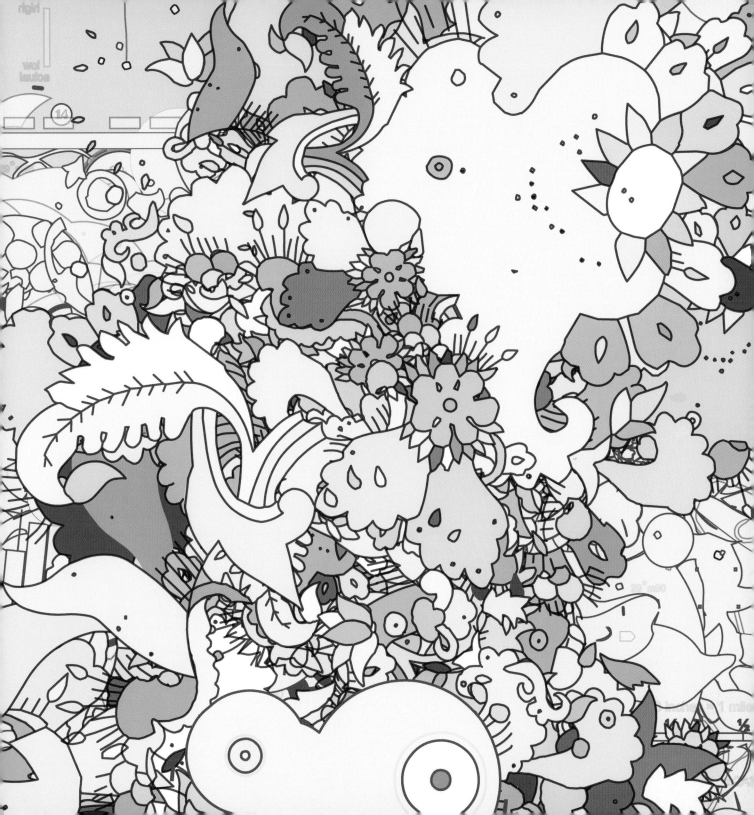

JAMES PATERSON (Canadian, born England, 1980), *Untitled VI*, 2005. Dye coupler print (chromogenic). Software: Macromedia Flash; output device: Durst Lambda 131. Sheet and image: 40 x 60 inches. Mary and Leigh Block Museum of Art, Northwestern University, 2007.22.2.

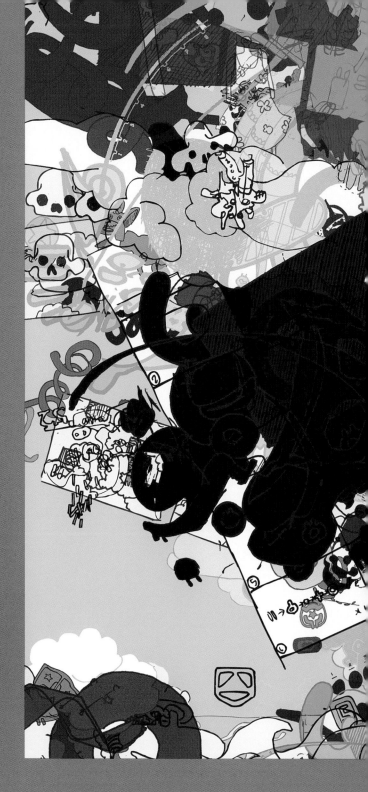

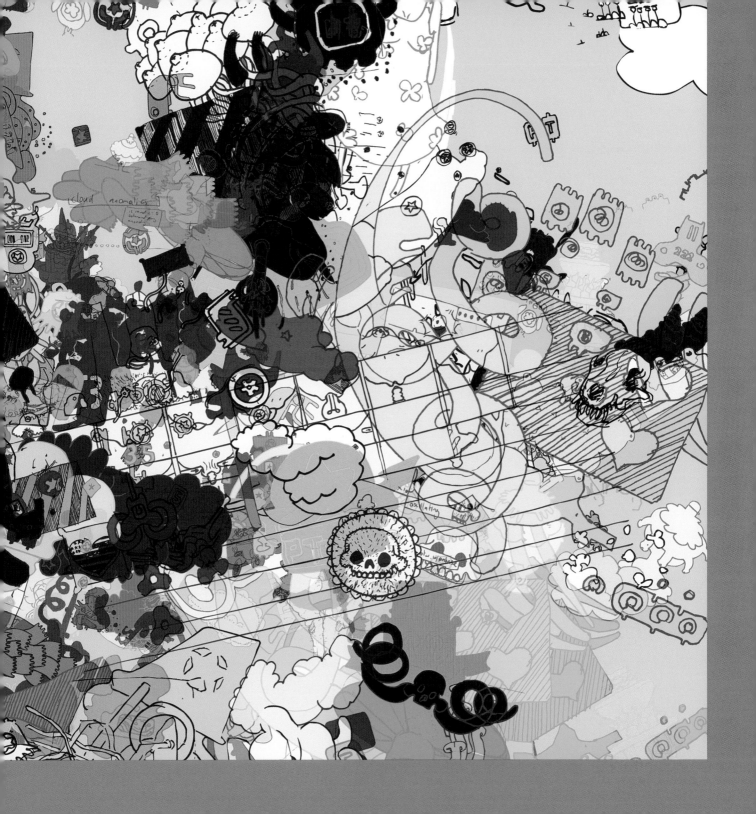

HAROLD COHEN (American, born England, 1928), *Copse No. 2*, May 2006. Inkjet print, diptych. Software, AARON, by the artist; output device: Roland printer. Overall: 92-1/2 x 93 inches. Collection of the artist.

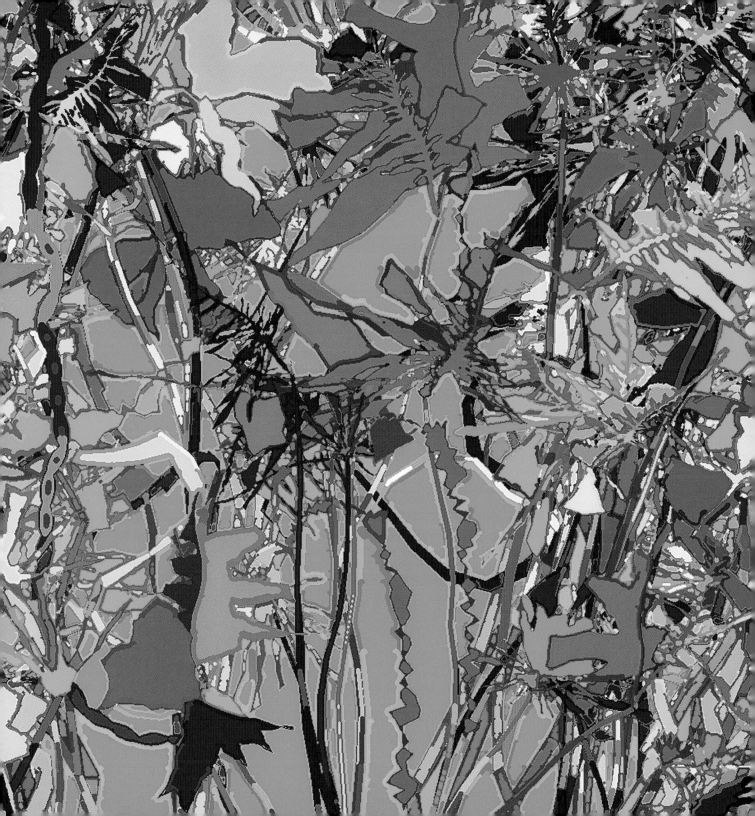

Published in conjunction with the exhibition *Imaging by Numbers: A Historical View of the Computer Print,* Mary and Leigh Block Museum of Art, Northwestern University, January 18–April 6, 2008.

This exhibition was made possible by the generous support of C. Richard Kramlich and was sponsored by Flashpoint, The Academy of Media Arts and Sciences. Additional support for the exhibition and related programs has been provided by the Illinois Arts Council, a state agency; the Lawrence Kessel Bequest Endowment; ACM SIGGRAPH; Hewlett-Packard; the Myers Foundations; and American Airlines.

Edited by Marianne Goss
Designed by Diane Jaroch
Printed in the United States of America by Lifetouch Publishing, Rockford, Illinois
Color separations by ProGraphics, Rockford, Illinois

10 9 8 7 6 5 4 3 2 1

Published by
Mary and Leigh Block Museum of Art
Northwestern University
40 Arts Circle Drive
Evanston, Illinois 60208-2410
www.blockmuseum.northwestern.edu

COVER: C.E.B. Reas, *17,* from the series *Path,* 2001 (detail). Inkjet print. Mary and Leigh Block Museum of Art, Northwestern University, 2007.22.3.

Unless otherwise noted, all photographs provided by the artists, copyright 2008.

Page 3: Courtesy of the Sanford Museum and Planetarium and bitforms gallery nyc; Photography by James Prinz.

Pages 4–9: Courtesy Kunsthalle Bremen—Der Kunstverein in Bremen (Germany); Photography by Björn Behrens and Michael Ihle, Bremen (Germany).

Pages 10, 11: © Charles Jeffries Bangert and Colette Stuebe Bangert; Photography Spencer Museum of Art, University of Kansas.

Page 12: Courtesy Manfred Mohr and bitforms gallery nyc; Photography by James Prinz.

Page 13: © Edward Zajec; Photography by James Prinz.

Pages 14, 15: Courtesy Kunsthalle Bremen— Der Kunstverein in Bremen (Germany); Photography by Björn Behrens and Michael Ihle, Bremen (Germany).

Pages 16, 17: © Joan Truckenbrod.

Pages 18, 19: © David Em.

Pages 20, 21: © Richard Helmick; Photography by Tom Van Eynde.

Pages 22, 23: © Sonya Rapoport; Photography by James Prinz.

Page 25: © Hans Dehlinger.

Pages 26, 27: © Mark Wilson.

Pages 28, 29: © Lane Hall.

Pages 30, 31: © Roman Verostko.

Pages 32, 33: © Jean-Pierre Hébert.

Pages 34, 35: © Paul Brown.

Pages 36–39: © Pascal Dombis; pages 36, 37: photograph of *Antisana II* installed at the Gallery Xippas, Paris in 2000.

Pages 41–43 and cover: Courtesy C.E.B. Reas and bitforms gallery nyc.

Pages 44, 45: © Tony Robbin.

Pages 46, 47: © Joshua Davis.

Pages 48, 49: Courtesy James Paterson and bitforms gallery nyc.

Page 51: © Harold Cohen.